How to cartoon Yourself in 10 easy steps.

by
Jarrod Knight

Jarrod Knight

Copyright © 2012 Jarrod Knight

All rights reserved.

ISBN: 1480214574
ISBN-13: 978-1480214576

How to cartoon yourself in 10 easy steps

For Claire, Bingo & Raffles.
Thank you for being my inspiration on a daily basis.

How to cartoon yourself in 10 easy steps

How to cartoon yourself in 10 easy steps

CONTENTS

About the author	i
Getting started	1
Step 1 - Eyes & Nose	6
Step 2 - The Mouth & Lips	10
Step 3 - Chin	12
Step 4 - Ears	14
Step 5 - Forehead & Head	16
Step 6 - Hair & Hats	18
Step 7 - Jaw line & Neck	20
Step 8 - Accessories	22
Step 9 - Review	24
Step 10 - Inking In & Erasing	25

How to cartoon yourself in 10 easy steps

About the Author

I was born in a little town called Mareeba, in Northern Queensland in Australia. But it was the city of Brisbane, where I grew up and was influenced by the world around me. I have been drawing and cartooning for as long as I can remember and as a child I would spend hours either creating my own characters, or copying them from my favourite comic strips and books.

At the age of 9, I created my very own cartoon strip and sent samples to the editor at the local Brisbane newspaper, The Courier-Mail. The editor responded in a letter, thanking me for my submission, telling me how impressed he was. He suggested that once I had actually finished school and gained more experience, I should submit some more work to him. For various reasons, I never did submit more work to The Courier-Mail, but that letter made it clear in my mind that cartooning and art was what I wanted to do.

Having trained at the Queensland College of Art in Brisbane while still finishing high school, I went on to study Commercial Art at Redland College.

I now live in beautiful Byron Bay, where I work from my home studio, writing and illustrating children's books, how to books, painting and creating comic strips.

How to cartoon yourself in 10 easy steps

GETTING STARTED

If you are drawing a cartoon portrait for the first time, then you are have the right book.
We will be drawing a profile portrait, which is a whole lot easier than drawing a face front on. It's a much simpler angle to start with.

WHAT YOU NEED

1. Pencil
2. Eraser
3. Paper
4. Ruler
5. Pen

WHAT YOU NEED TO KNOW

- I would suggest using a photo to draw from. Then you have a constant reference point right next to your drawing as you do it. If you are drawing yourself, why not pull a silly face and take a picture with your phone.

- Take some time before you start and have a good, long look at the picture. Remember this is all about having fun. Search for those distinctive features to really emphasize. If you are drawing yourself, now is not the time to be self conscious. Have some fun at your own expense.

I'll be drawing a portrait step by step from the picture below. This will give you examples of what I'm teaching you and show you how easy it is!

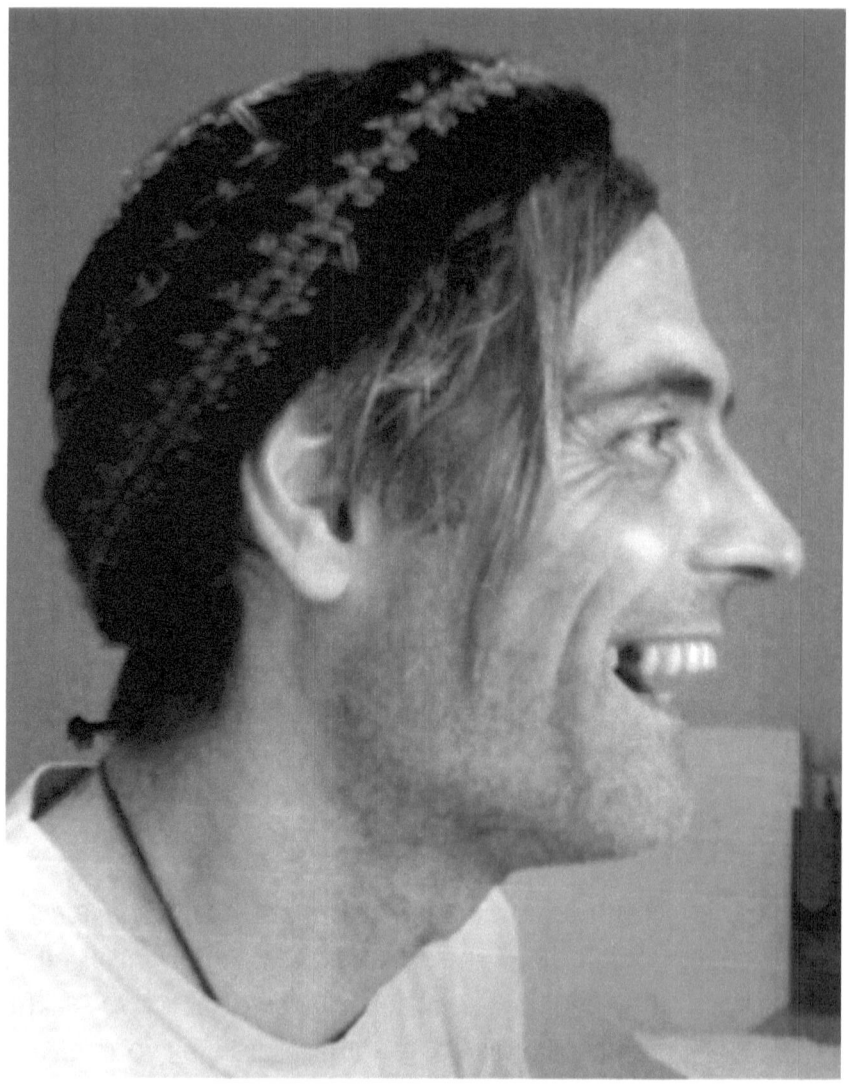

WHAT YOU NEED TO REMEMBER

- A cartoon is just a series of lines and shapes.

- Take what you see and simplify it into basic shapes. Before you draw a feature, look at the picture and squint. Then draw a basic shape lightly (like a long, pointy triangle for a nose) that best represents what you see and use that as a guide as you draw that feature.

- In each step you will draw a different feature, building slowly but surely to your final cartoon portrait.

- Draw all the features lightly with a pencil, because at the end you will go over your portrait with a pen and erase all the unwanted pencil lines.

- Take some "artistic license" when drawing features of people. It's a cartoon, not a serious sketch of someone. Think of all the political cartoons you've seen. Most are very basic and focused on the prominent features and characteristics of the person.

- As we go through and add features, you may need or want to adjust previous features you have drawn to suit what you are adding.

- There is no wrong: it's your creation!

- There are no mistakes: only learning experiences.

- You may not get the result you wanted the first time, but there WILL be good things about what you have drawn. So just draw it again!

- The only rules are the rules you place on yourself.

HAVE FUN AND BE CREATIVE!

STEP 1 – NOSE & EYES

- It's always good to start with the nose and eyes as they are at the centre of the face. You can then build the rest of your profile piece by piece from there.

- Whether you draw the eyes then the nose, or the nose then the eyes, it is totally up to you and what you find easiest.

Nose

- I'm going to draw the nose first because that's what I find easiest for me with this portrait.

- Remember, this is a cartoon so if it's big, draw it even bigger! Noses are one of those facial features that cartoonists like to have a lot of fun with and really help in creating a funny portrait.

- Look at the top edge of the nose and at how much it angles, it's length, and how bumpy or smooth it is.

- Now look at the tip and the underneath. Does it hook over at the end or is it round like a light bulb at the tip? Is the nose turned up or does it point down?

And don't forget those nostrils!

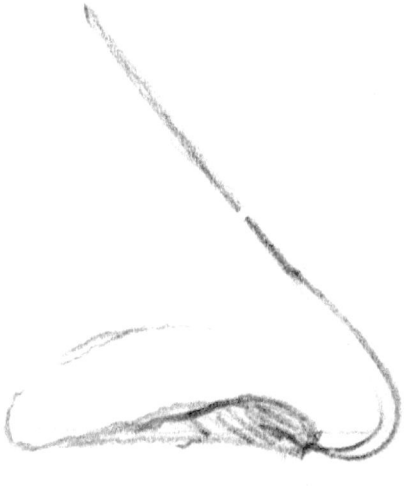

Eyes

- Look at the shape of the eyes closely. Are they big and round or are they beady and narrow? Take what you see and simplify it into basic shapes.

- We are also going to add the cheeks (if they are a prominent feature) and the eyebrows in this step, because they are both a part of the look of the eye.

- Take note of, and add if you want, any laughter wrinkles around the eyes as well as eyelids.

- When you draw the eyebrows, there are a few different techniques, and your use of these depends on the eyebrow you're drawing. If it's a really thin brow then a simple line may do. Whereas if the brow is really thick then you could draw a big, dark shape or a series of thick, squiggly lines that best represents the eyebrow of the person you are drawing.

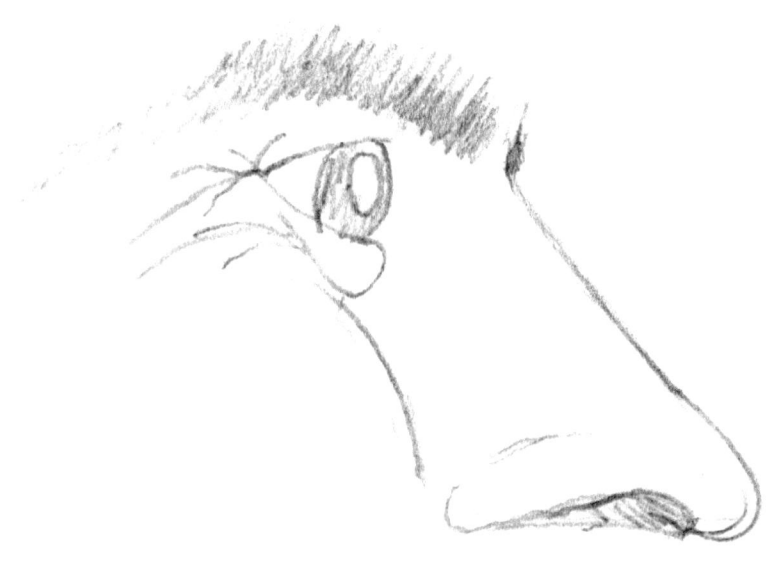

The eyebrow that I'm drawing has an average brow in terms of thickness. So I am going to use a series of lines on an angle.
I also added part of the cheek and the wrinkles around the eyes because they have a big smile and that helps to accentuate that characteristic.

STEP 2 – THE MOUTH & LIPS

- Notice the space leading down from the nose to the chin, and the angle it is at.

- Check out the mouth and whether there is an over bite, under bite or the lips are perfectly lined up.

- Are the lips big and full, or thin? Or is the top lip thin and the bottom lip thick and full or vice versa?

- If someone has a moustache then, obviously, you must draw that. So focus on the outline and the shape of the moustache and really expand on any characterizing shape to it you may see.

- Teeth are, of course, part of the mouth. So if they are a prominent feature of the person you are drawing, then draw away as big or small as you see fit.

- Now is the time to also add things like wrinkles or dimples that may appear around the mouth.

How to cartoon yourself in 10 easy steps

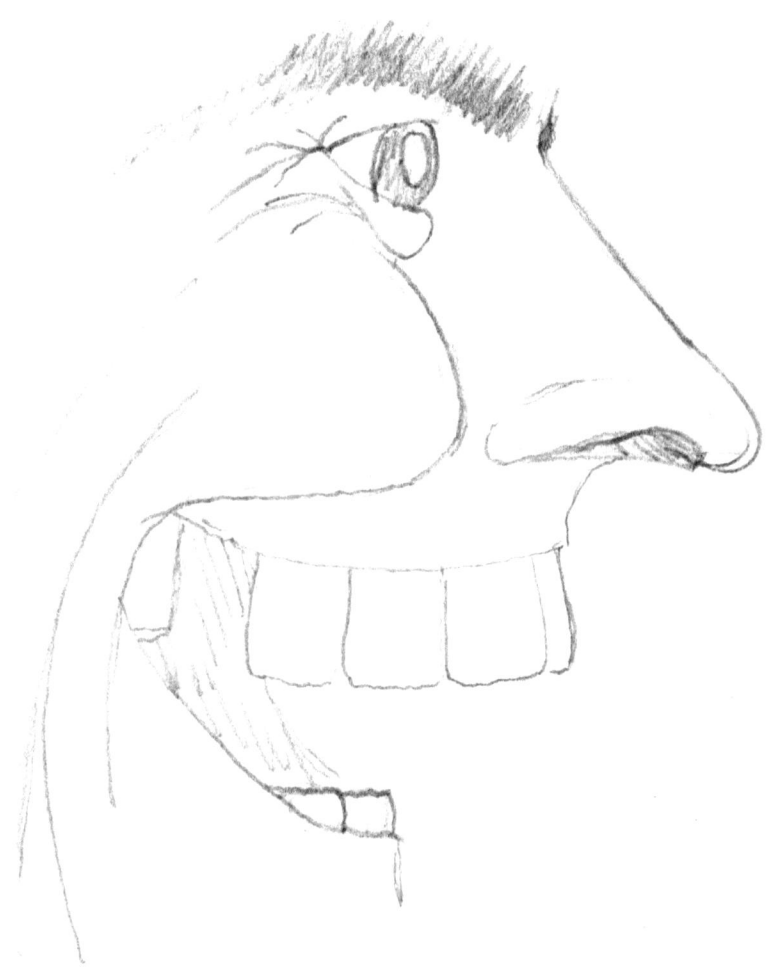

On this portrait, there is an obvious missing tooth and prominent wrinkles around the mouth because they're smiling. I also emphasized the overbite they have by drawing the lower part of the mouth further back.

STEP 3 – CHIN

- Take your time and look at the chin. Is it a key feature of this person's face? Some people have really big, prominent chins, and others have chins that almost do not exist and just fade away into their neck. What do you see?

- As I said before, if it's big, draw it even bigger!

How to cartoon yourself in 10 easy steps

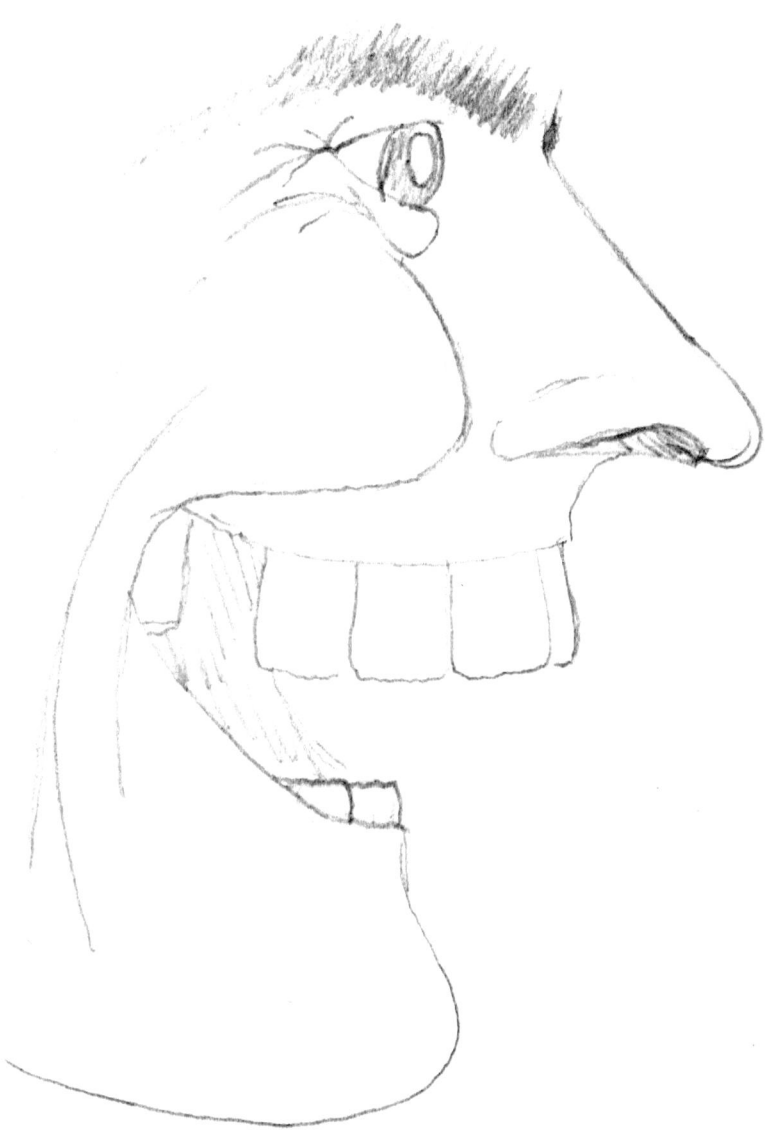

STEP 4 – EARS

- Does the person you're drawing have small or big ears? Like noses, ears are one of those facial features that cartoonists like to have a lot of fun with and really help in making a great portrait.

- If the ears are partially hidden due to hair or a hat, draw the ear like it is all there anyway. Later you can cover it up or erase what you don't need when you come to do the hair or hat. Having the entire ear there will help you with placement of other features.

- When it comes to placement of the ears, the top of most people's ears are in line with their eyes.

- Also we need to now take into account the entire head and its shape. So we can place the ears as far away or as close to the eyes for best effect and the best representation of the person we're drawing.

How to cartoon yourself in 10 easy steps

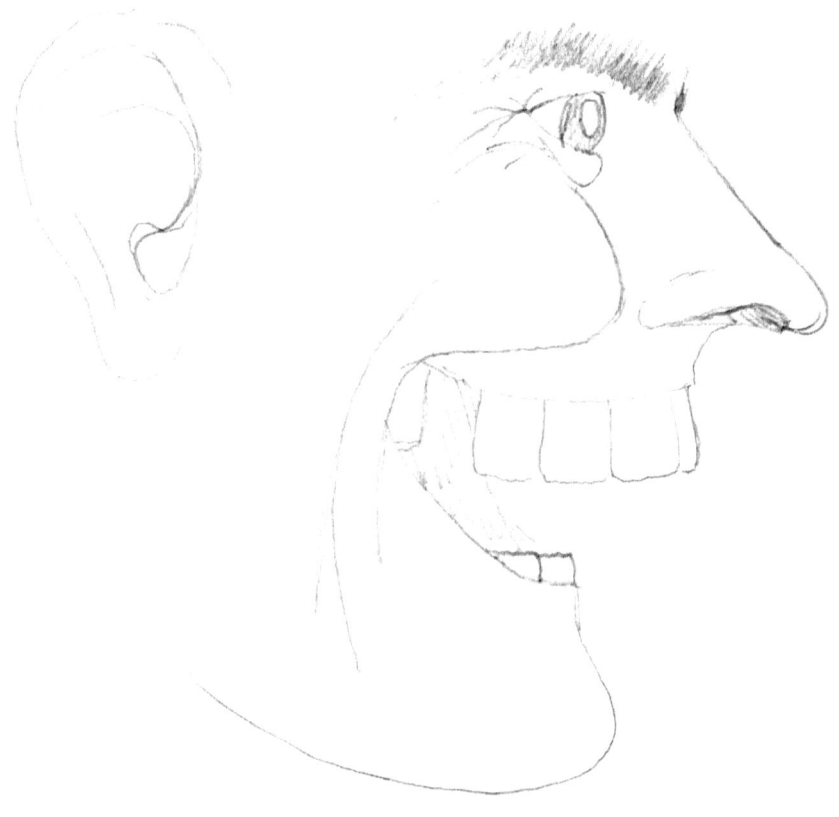

STEP 5 – FOREHEAD & HEAD

- Study the shape of the forehead leading up from the nose and brow to the hairline.

- Then look at the rest of skull and draw a light line from the nose/brow area around to give you a basic shape for the head. You can then use this as a guide when you come to add features like hair and hats.

How to cartoon yourself in 10 easy steps

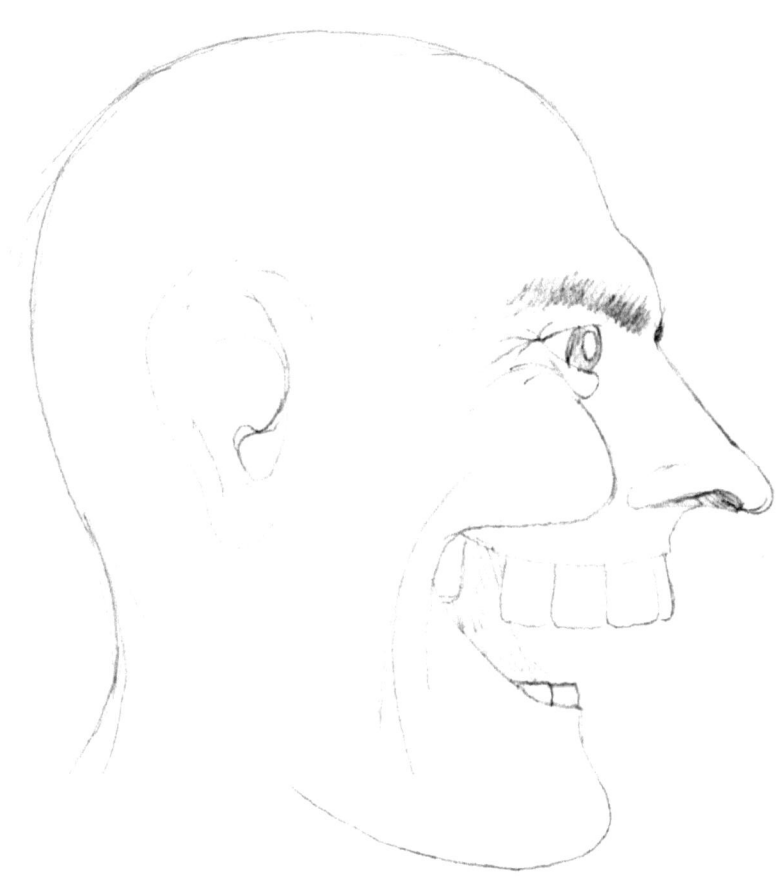

STEP 6 – HAIR & HATS

- Now it's time for the hair and a hat if your subject is wearing one.

- First you must draw the hairline and the hair that surrounds the face. Look at how it hangs, or stands up, and the direction of the strands of hair. Some hair you can get away with just drawing the outline with a few lines to represent the strands. However those people with messy, tangled or curly hair may need a bit more detail.

- If your subject has a hat, now is the time to draw a basic outline of the headwear. Give it some texture down near the back and draw some lines for texture should the hat have stripes, segments or weaves. Then draw the hair coming out the back of the hat onto the neck.

- For those without hats, draw the outline of the hair from the top of the skull around and down to the back near the neck.

- You can then draw some strands coming down from the top of the skull and down the side for texture. And maybe a few lines to represent strands for texture on the side near the ear.

How to cartoon yourself in 10 easy steps

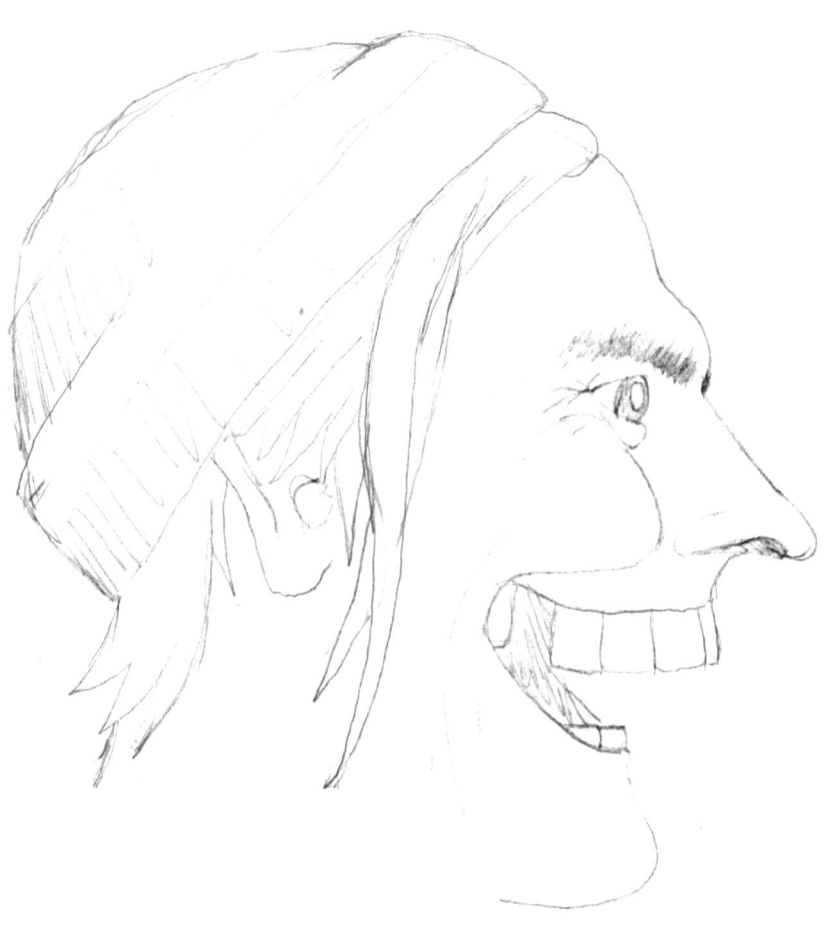

STEP 7 – JAW LINE & NECK

- It's time to draw the jaw line from the chin around to the bottom of the ear.

- As with other features, take some time to look at the shape & angle of the jaw before you start.

- You don't have to draw one continuous line up to the ear if you don't want to. Some jaw lines are bold and strong and yes a continuous line may well represent what you see. But some are less defined, so hence one line is not needed. Just represent enough of the jaw to know it's there.

- If someone has a beard then obviously you must draw that. So focus on the outline and the shape of the beard and really expand on any characterizing shape to it you may see.

- Of course, like the nose and ears, some people's jaws can be a very distinctive feature, so really have fun with it if in fact it is a major characteristic.

- If they have a really thin neck, to emphasize it, make it longer. Do the opposite for someone with a thick neck, make it really short and wide. Look at the length, shape and size of the Adams apple if your subject is male.

How to cartoon yourself in 10 easy steps

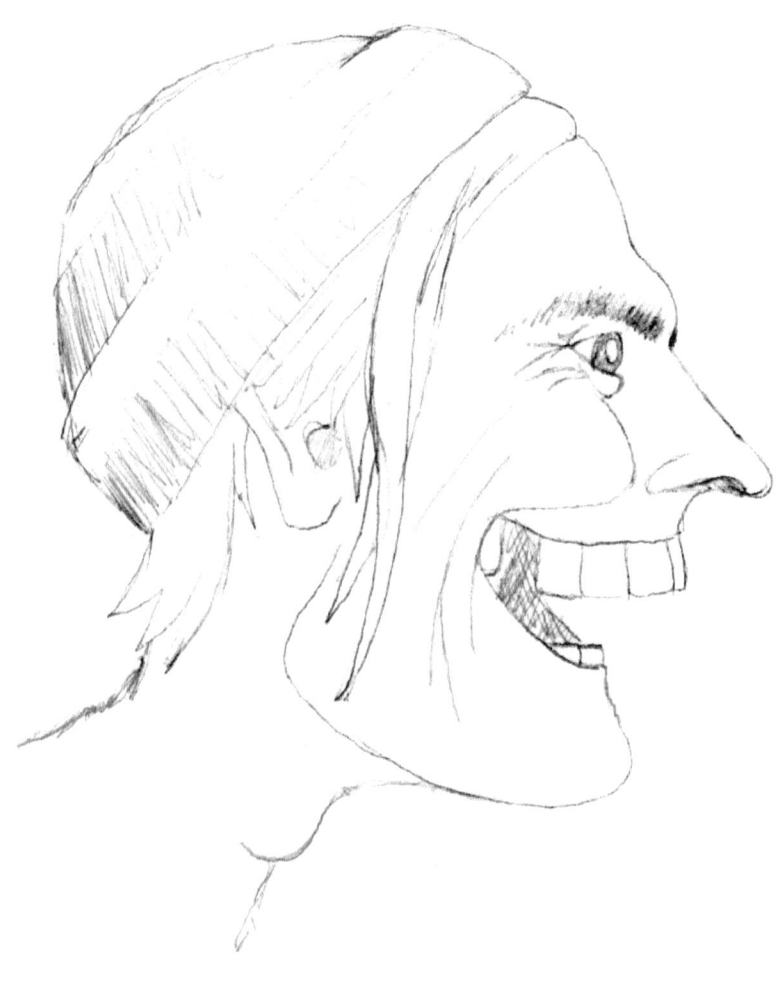

STEP 8 – ACCESSORIES

You are nearly done!

- Now you may want to add bits and pieces like piercings, tattoos, jewellery, collars or even more of the upper body like shoulders and chest. Adding the shoulders and the chest can help with the overall effect if perhaps you drew a long, skinny neck or a really thick almost non-existent neck.

- Whatever it may be, as you no doubt know by now, look at the shape, angles and size of what you are adding before you draw.

How to cartoon yourself in 10 easy steps

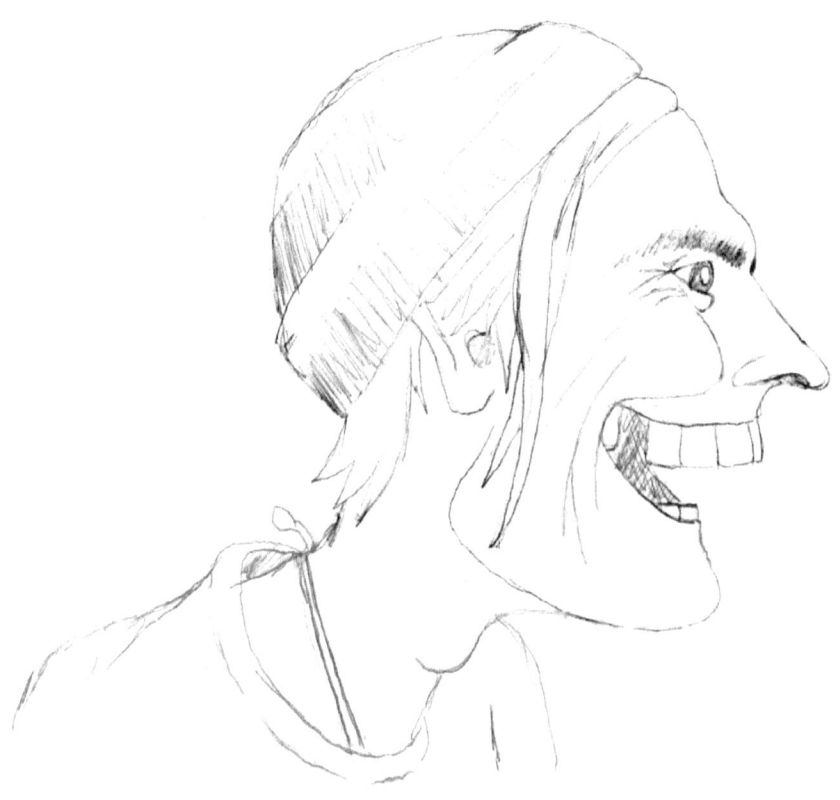

STEP 9 – REVIEW

- It's time to look at what you have drawn and congratulate yourself on a great job!

- BUT MAYBE you can see that you need to adjust some features that, now you have finished, you think could be bigger, smaller, rounder, straighter, more crooked, less crooked, more pointy or even less pointy. Whatever it may be now is the time to fix it.

STEP 10 – INKING IN & ERASING

This step is optional: You may want a pencil cartoon that looks great exactly as it is.

- Now all that is left to do is ink in the lines you want to keep and erase the ones you don't. Revealing your masterpiece!

- It's easiest to use a pen with a fine to medium sized nib on it. If your pen is too thick you may lose some of the detail on your drawing.

- Take your time while doing this. You've come this far and it would be a shame to accidentally ink in a line you didn't want to.

- Now you've gone over all the lines you want with ink. Wait a minute or two to allow all the ink to fully dry before you start erasing the unwanted pencil lines. If the ink isn't dry when you erase, it'll smear and smudge.

- Now it's time to erase. Do it slowly in one direction. If you erase back and forth on the one spot you risk catching the paper, causing it to crumple up, or even worse, rip the page.

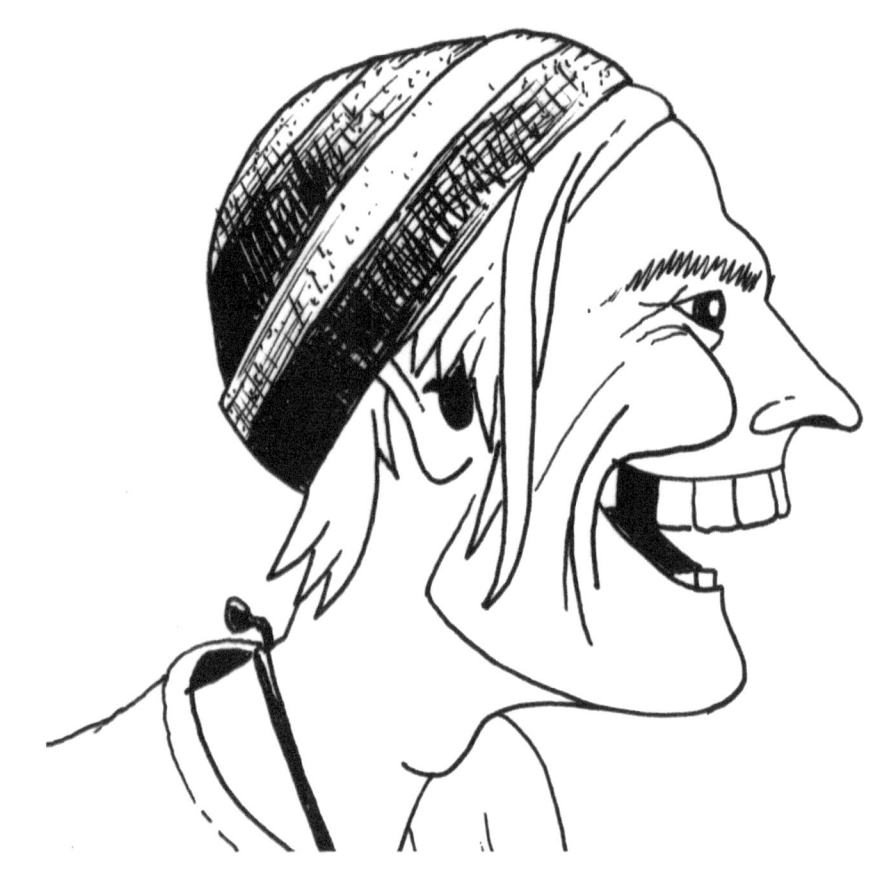

CONGRATULATIONS

You have finished your portrait!

Other books by Jarrod Knight:

How to Cartoon a Dog a Million Ways in 10 Easy Steps

Coming soon from Jarrod Knight:

How to Cartoon a Cat a Million Ways in 10 Easy Steps

Muffin & Yellephant

Mary from Scary

How to Entertain Children with Live Ammunition: The Terry the Clown Collection.

All available from www.jarrodknight.com

www.ingramcontent.com/pod-product-compliance
Lightning Source LLC
Chambersburg PA
CBHW021853170526
45157CB00006B/2422